regarding

madeleine lee

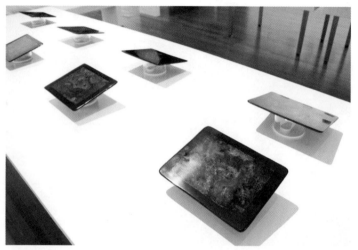

Phi Phi Oanh. Exhibition view of *Pro Se* (detail).
2016–2017. Lacquer on wood, 24 x 18.5 cm (each).
Collection of the artist, commissioned by National Gallery Singapore.

a quick dart into the viet lacq show
finds a fence of ipad-size pieces
tablets in gold leaf
etched multi-hued layered
colour on black
black on black
blurred sharp pixelated
like prisoners tethered
by tensile wires to acrylic stands

quite like those in the apple temple
not far up the shopping road

please touch
please do not touch
the signs continue to contradict
as i attempt to write
verse on
pro se

in the next gallery
a young boy throws a tantrum
perhaps he didn't get the
latest gadget model of the day
the fairies writ large
in exhibit 'a' too busy posing to oblige

2

dotty

Exhibition view at Singtel Special Exhibition Gallery A, City Hall Wing,
National Gallery Singapore, 2017.

i **circle**

the problem with a circle
where does it start or end
what does it enclose or ringfence
what does it encompass
how to get inside
the circle inside her head

she held the crayon with all five fingers
drawing potatoes on the paper

ii **nets**

at first it spins within
the limits of her head
just how elongated
depends on eccentricity

the sparks rub the membrane
the inside of the skull
leaving small burn marks
elliptical almost round
running in infinite loops
she can't get out

when fixing the race tracks
for the battery-operated blue and red cars
she found pieces enough only
for an elliptical track a beginner's set
as she pressed the controls the cars left sparks
in the central contact gully

iii ball

said a very wise man
everything is reductive
reducible redactable
into nothing

the opposite happening now
everything is reflected
refracted readapted
into everything
the ceiling the surrounding
the wall the floor
all become plural
we become everything
yet nothing at all

in a room filled with hundreds
of mercury droplets
breathless
what do they all add up to

the pachinko machine
screeched for more
insatiable for ball bearings
she fed and fed it
forgetting her baby's screams
in the car seat in the car in the parking lot

iv **orange cells**

which came first
the fruit
the colour
the duke

so all things lead to another
so all things come asunder

they look like cells he says
as the orange spots dance
in front of his colour–blind eyes

when he was young
there was an orange soft drink
called green spot

the mitochondria swim silently
in the cytoplasma worming
as organelles do

if sliced horizontally
they look like the schemes
for clever pin ball machines
designed to lose you your marbles

unafraid
to signal of life and death
carrying their own genome

v synthesis

the tulip looks up to the sun
to bathe in white light
the light breaks into pantone registers
showering down in big drops
onto blank canvas
do we see
flower or colour
dots or space

she learnt that in potato printing
with a dug-out pattern one can almost
certainly guarantee big blotchy prints
of roundish clumpy undefined outlines
on a white drawing paper

vi square

at the junction where 7th crosses broadway
there is a small opening
into a tall cupboard
step inside to see walls of mirrors
bouncing off neons of every colour
flickering at every speed
even with eyes closed the chasing lights
remain in retentive retinas

kneeling to reach child height
i look in child like
a new age japanese disco she says
is disco even a word for millennials
dizziness comes with cover charge
not the highs which are a la carte

at christmas she was given a kaleidoscope
fairies in a cardboard tube
when older she began to wonder
how insects felt with their compound eyes

vii **black and yellow**

the long line gets restive
over the prospect
of dotty immersion
in a box of spots and mirrors
tear along the dotted line
a yellow sticker of privilege
gives her priority
to get her visual senses thrown about
in 4,8,16 directions

the black spots really appeared
in front of her
like when as a child
she rose too quickly from a squat

viii **mono**

emerging from fuss and busyness
onto a landing of white marble with grey accents
we come face-to-face with monochrome
the infamous pumpkin the size of an armchair
dressed in black and white mosaic
nothing else
quite a relief

if at the stroke of a wand
it became a stagecoach
what colour would be the livery

at the end of a colourful life
may it be clear as black and white

ix point

uncannily
she chose
to wear a
polka dotted dress
to a kusama show

3

national
language

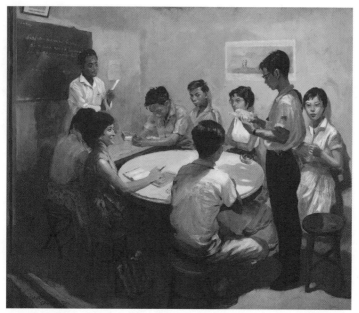

Chua Mia Tee. *National Language Class*.
1959. Oil on canvas, 112 x 153 cm.

in a place of pride
in the pride of place
is our national language
mute and silent

chegu
wears a darker sheen
set against a shirt in brighter white
as if to differentiate
he is older
has the mustachio
and the requisite
not one but two pens
in his shirt pocket
he holds
a pencil or ruler or chalk
it is hard to tell
he is somewhat in the shadow

a chinese boy
bespectacled
holding a book turned
to the lesson of the day
saying his name
what is your name
siapa nama kamu
only it is hard to say
his teochew name
with bahasa intonation

his thoughts distracted
he has only recently lost
a parent the coarse jute square
still pinned to his left sleeve
and if only ah keng next to him
would stop twirling his pencil

the girl in the blue green dress
with the mandarin collar grins
she is the only one
whose parents can afford
the new edition of the buku teks

up front the boy in a
used-to-be white now grey shirt prays
he does not get picked
he strikes a confessional pose
having sworn on chegu's dictionary

the trick in a low teacher-to-student
ratio class is to cultivate looking askance
approximately fifteen degrees to one side
preferably looking about two feet
from one's nose into the near field
always looking meaningfully
always looking sincerely
at nothing
even better if aided by a pair
of cat's eye reading glasses

on close inspection
when asked about
our national language
one finds
everyone looking
everywhere but
at themselves
wishing they would vanish

like the girl
in the red floral skirt
who has hidden herself
almost completely from view

4

apa nama

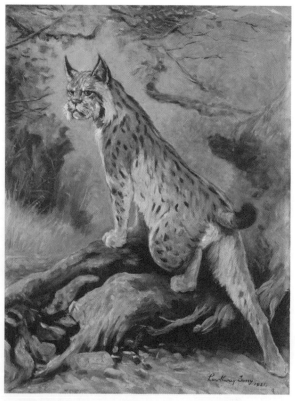

Low Kway Song. *Lynx.*
1921. Oil on canvas, 58.5 x 45 cm.
Collection of Low Keong Hee Richard & Low Keong Ann Arthur.

i **feline**

much made of the tiger
under the billiards table
less so about the lynx
a mere cat a mere civet

it looks like a cross to me
front legs on a rock
its face turned back
in a stare

almost human expression
almost human lambchop sideburns
so clear the disdain
the unforgiving glare

in the myth of the nation
the lion is legend
the tiger is consort
the lynx fabulous

all cats after all
what's in a name

ii mr loh

mr loh held the paper fan in his right hand
calligraphy ran across the accordion fold
he had on his best silk brocade ma-gua
black mandarin jacket and moustache
a literal picture of a literati

mr loh held the paper fan in his right hand
his smoother prosthetic right hand
lost earlier in the brickworks of redhill
he has made his fortune so now he is entitled

iii incik

as if in contrast
to erase paid work
incik in the next portrait
has no name

just a malay man
in a black songkok
and green sarong
untitled unfinished

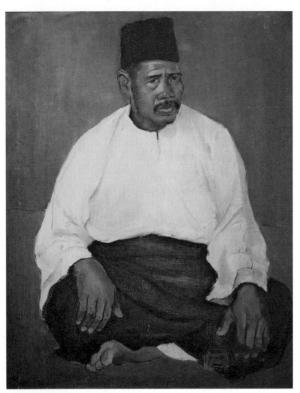

Tchang Ju Chi. *Untitled, Unfinished*.
c. 1942. Oil on canvas, 80 x 61.5 cm.
Collection of the late Dr Ho Kok Hoe.

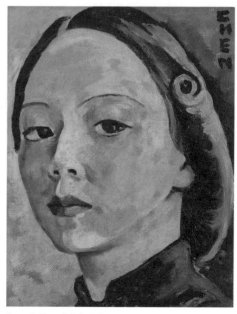

Georgette Chen. *Self-Portrait*.
c. 1946. Oil on canvas. 22.5 x 17.5 cm. Gift of Lee Foundation.

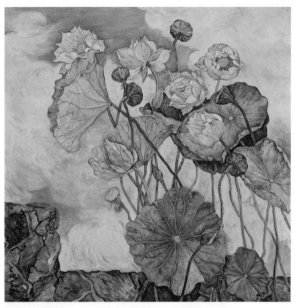

Georgette Chen. *Lotus in a Breeze.*
c. 1970. Oil on canvas, 81 x 81 cm. Gift of Lee Foundation.

iv **georgette**

as she aged she painted herself
younger
brighter complexion
milkier skin
elegantly styled hair
newer cheongsam

she longed for simple things
just a walk outside the garden walls
just to flow with the breeze

as the georgette scarves did
on the gorgeous necks of parisian women

later when more mellow
she rendered
tropical fruits
gloriously hairy and gnarly real
and lotuses
freeing themselves from a muddled past

v **what's in a name**

apparently something
if one doesn't have one
then best to drop one

especially if king leopold
is a blood relative

such that a mere mention
gets a reprieve and an extension
in the painting of toplessness in bali
so far away from victorian priggishness

vi nanyang

wo men xia nan yang ba!
so he exclaims as he sets sail

south southerly lee-ward
towards the treacherous jaws
of the dragon's teeth

to tumasik
then once more
south east to batavia
then on a boat to bali

a brown fisherman
in brown sarong
left hand on the rudder
right on his knee
his glance askance

behind him a carved mask
in black with googly eyes
for luck for safe passage

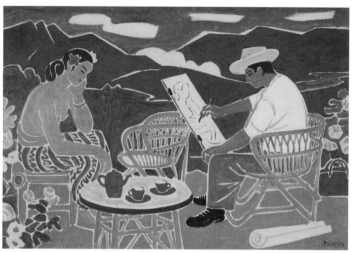

Liu Kang. *Artist and Model.*
1954. Oil on canvas, 84 x 124 cm.
Gift of Shell Group of Companies, Singapore.

vii **nanyang style**

the further south they go
the deeper the sea salt
embeds in the pores
sticks to the canvas

he paints him painting
she poses he sits
temple offerings pile
on top of the ebony

a new identity evoked
stroke by brush stroke

viii **tegur**

in this new world
unlicensed is unnamed

unspoken
coded
admonished

the inspector comes
the street hawker runs

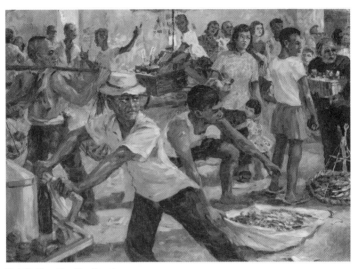

Koeh Sia Yong. *Here They Come!*.
1965. Oil on canvas, 85.6 x 119.5 cm.

ix **lion**

what is country

pan shou waves his calligraphic wand
eng seng casts his abstract net
tze peng scoops falling shophouses

chai-hiang whitewashes a square

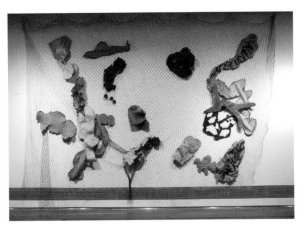

Teo Eng Seng. *The Net: Most Definitely the Singapore River.*
1986. Paperdysculp and net, 350 x 350 cm. Gift of the artist.

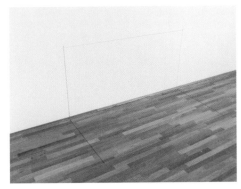

Cheo Chai-Hiang. *5' x 5' (Inched Deep).*
1972, remade for display in 2015. Mixed media, 150 x 150 cm.

5

after the
rain

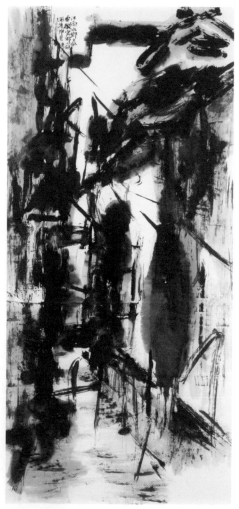

Chua Ek Kay. *After the Rain*.
2004. Chinese ink and colour on paper, 244 x 120 cm.
Singapore Art Museum collection.

i **after the rain**

she watches
late november sky
drips in slow motion
like the story teller
on boon tat street
tells his tale slowly
to earn one more
joss stick worth of coins

the makeshift tarpaulin
once duck green
now a mottled black
drip
drying like
a chinese ink painting
the spread of shadowy
water stains shrinking
drip drip
in slow rewind
drip drip drip

after the rain
the sky is just
one shade of grey

ii blue window

but she peers
out of a scratched
glass square
reflecting the
lightening sky
turns into a
blue window
against black-mould
seeping walls
it becomes a
mondrian
in a gallery

iii **awaiting a dragonfly**

she dashes up
the spiral stairs
behind the
long chinese house
on telok ayer
to check that her
rooftop garden
a few pots of frangipanis
pomegranates jasmines
water lilies lotuses
are not washed away
by the sudden monsoon

on the edge
of a dragon urn
a lotus bud
halfway open
somewhat cautious
awaits the fleeting visit
the buzzy titillation
of the wings of a dragonfly

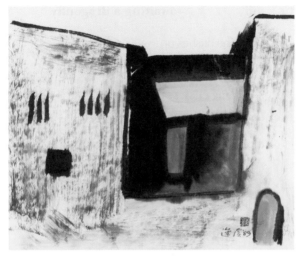

Chua Ek Kay. *Blue Window*.
1989. Chinese ink and colour on paper, 50.5 x 62 cm.
Singapore Art Museum collection.

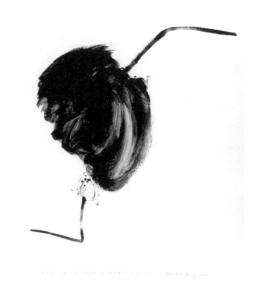

Chua Ek Kay. *Awaiting a Dragonfly*.
2002. 6 colour lithograph on handmade paper, edition 7/30,
107.5 x 81 cm. Gift of Yuji Inoyama. Singapore Art Museum collection.

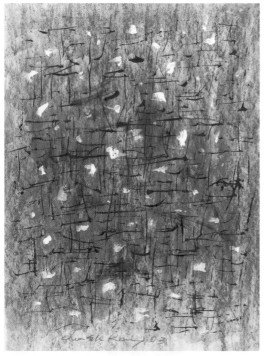

Chua Ek Kay. *Morning Frost.*
2003. Chinese ink and colour on paper, 51 x 39 cm.
Gift of the artist. Singapore Art Museum collection.

iv **morning frost**

the courtyard covered
in small pock marks
where a cheap mix
of cement and sand
confessed
in some moss grows
in others puce lichen
close up
the ground looks a lot
like morning frost

v connaught bridge

from chinatown
she crosses cross street
across malacca steet
stepping into puddles
to reach boat quay
the lighters berth
the coolies take shelter
and a smoke break
from the tropical storm
their white singlets
still drying in blotches
from number seventy-one boat quay
she looks across the murky river
the colonial lines drawn
along connaught bridge

Chua Ek Kay. *Connaught Bridge*.
1997. Chinese ink and colour on paper, 66 x 96 cm.
Gift of the artist. Singapore Art Museum collection.

vi　　　　**lotus**

retracing
she enters
mazu temple
in the main courtyard
a granite trough
once drinking water for horses
now filled with lotuses
in pink and white

Chua Ek Kay. *Lotus.*
Undated. Chinese ink and colour on paper, 127 x 67.5 cm.
Singapore Art Museum collection.

Chua Ek Kay. *Back Lane*.
1991. Chinese ink and colour on paper, 70 x 96 cm.
Singapore Art Museum collection.

vii backlane

the back alley
tempts
where amoy meets telok ayer
a hawker beckons
sultry prawn and pig tail soup
drenched in salty sweat
snarling in a big aluminium pot
from the right basket

she picks up her pace
well-worn cast iron saucepan
with re-taped handle in hand
past evaporating blue grey walls
her black and white samfoo
contrasts

6

imaginings

i **imaginings**

who could have guessed
what the prisoner would have said
a hundred years ago
led from lock-up
onto hidden stairs
and upon emerging
find himself today
time travel-like
bursting into room one
once courtroom number one
a wood-panelled chamber of
drawings of various asian kings
facing off pale-faced bewigged lawlords

ii dutch courage

it must have taken a broad brush
to whitewash
colonial history
the mooi indie
dutch-speaking conqueror-painter
presents in soft focus
in oil as if watercolour
javanese landscape and tableau
inevitably rice planting
overlooking backbreaking

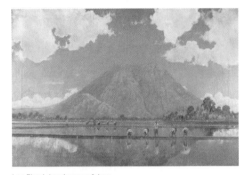

Leo Eland. *Landscape of Java.*
1929. Oil on canvas, 106 x 156 cm.
Collection of Nationaal Museum van Wereldculturen, TM-3356-1.

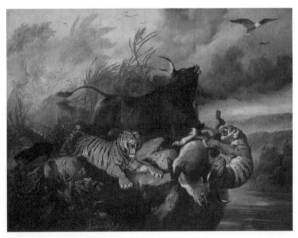

Raden Saleh. *Boschbrand* (Forest Fire).
1849. Oil on canvas, 300 x 396 cm.
This work of art has been adopted by the Yong Hon Kong Foundation.

iii **ring fence**

in the business of maximum profit extraction
from clove trading the dutch east india company
the voc put a ring around the clove forest
they want and set the outliers to burn

animals disperse
in the forest fire
in the ensuing haze
upon reaching the brink
find little room
the tiger hangs on
by its fearsome claws
mother buffalo looks
behind for her young

clove flavoured smoke overpowers snuffs
a search for liberty and survival smoked
out by overpowering fiery master
as kretek cigarette smoke blackens the lungs

iv **looming**

when at last independence arrives
and elections loom
the intent gaze at the hustings posters
look left or look right
socialist or king
sharing or uncaring
people or power
art imitates
the answer is unfinished

v **guerilla**

the young man smooth skinned
his mentor scaly reptilian and a shade of green
the young man has long hair tied back
his mentor has wild curls and chin like an emin bed

out east the mountains are at peace
oblivious to the common denominator
common aim common detonator
shots fired to drive out the occupiers

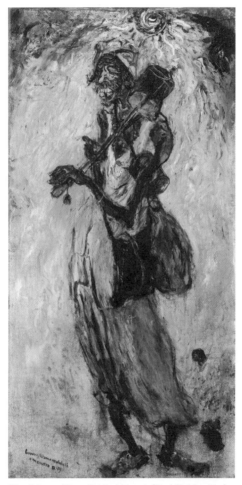

Affandi. *Burung Hitam, Matahari, Manusia* (Black Bird, Sun, Man).
1950. Oil on canvas, 169.5 x 84.5 cm.

vi blackbird singing in the light of day

what's in a brush what's in a stroke
more trappings of western thought
he squeezes his mind for inspiration
he squeezes from tubes his juggernaut
no medium no agent no screen no censor
the sun man has a crinkly smile of art tube wrinkles
wonder where he is going long dress satchel slung
the sun on his left shoulder on his right the blackbird sung

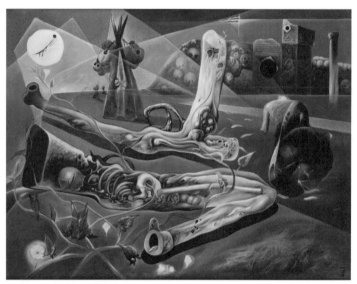

Pratuang Emjaroen. *Red Morning Glory and Rotten Gun*.
1976. Oil on canvas, 133 x 174 cm.

vii yank

to them it is the vietnam war
to us it is the american war
best to know on which side to fight
then american in asia now asian in america
where you are depends on where you stand
when rebelling with non-violent means
thus he paints the rifles at melting point

viii **quite contrary**

 mary mary extraordinary
 docent to the boys and girls
 she points to the drawings
 to solicit some rumbling
 hoping to awaken the art monster within

Madeleine Lee is an investment manager who also writes poetry. This is her 10th volume of poems, completed during her stint as Poet-in-Residence at the National Gallery Singapore.

The poems in this volume emerged from Madeleine's visits to the following exhibitions.

pro se: *Radiant Material: A Dialogue in Vietnamese Lacquer Painting*, National Gallery Singapore, 5 June–3 September 2017.

dotty: *Yayoi Kusama: Life is the Heart of a Rainbow*, National Gallery Singapore, 9 June–3 September 2017; Queensland Art Gallery | Gallery of Modern Art, Brisbane, Australia, 4 November 2017–11 February 2018.

national language and apa nama: *Siapa Nama Kamu?: Art in Singapore since the 19th Century*, a permanent exhibition at National Gallery Singapore.

after the rain: *Chua Ek Kay: After the Rain*, National Gallery Singapore, 26 November 2015–30 October 2016.

imaginings: *Between Declarations and Dreams: Art of Southeast Asia since the 19th Century*, a permanent exhibition at National Gallery Singapore.

Published in 2018.

Please direct all enquiries to the publisher at:
National Gallery Singapore
1 St Andrew's Road
#01-01
Singapore 178957

Managing Editor: Elaine Ee
Project Editor: Genevieve Ng
Designer: Madeline Lim

Image credits:
Page 20: courtesy of Madeleine Lee

National Library Board, Singapore Cataloguing in Publication Data
Names: Lee, Madeleine. | National Gallery Singapore, publisher.
Title: Regarding / Madeleine Lee.
Description: Singapore : National Gallery Singapore, 2018.
Identifiers: OCN 1041840916 | 978-981-11-6642-6 (paperback)
Subjects: LCSH: Singaporean poetry (English)
Classification: DDC S821--dc23

Printed in Singapore